SOME SERIOUS,
SOME NOT,
SOME NOT EVEN THAT

GEORGE WYLLIE

Collected Poems & illustrations 1979 — 2010

SOME SERIOUS, SOME NOT, SOME NOT EVEN THAT

—

BY GEORGE WYLLIE

Foreword by
Liz Lochhead

MEDIA MATTERS

with The Whysman Festival

—

A Media Matters Book

First published in 2012 by
Media Matters Education Consultancy Ltd
104 Barscube Terrace
Paisley, PA2 6XH
www.mediamatters.co.uk

Cover design, typography & layout: www.pgerossi.co.uk
Complied by: Louise Wyllie, Pete Rossi & BCA
Printed in Great Britain by Lightning Source UK Ltd

Published by Media Matters Education Consultancy Ltd
in association with Beautifully Crude Arts & The Whysman Festival
www.beautifullycrudearts.co.uk
www.whysman.co.uk

ISBN:
978-1-907693-10-6

"George Wyllie is a seriously playful artist... His structures are poems, just as all the poems in this book are structures."
— *Liz Lochhead, Scots Makar (national poet)*

"These wise odes, whether serious or not, are best hummed to the imagined strum of the Hawaiian clarsach, the wry bard's name for his ukelele. That's a word meaning 'jumping flea' in those far off Pacific islands, itself a poetic stroke of Wyllie's surreal magic."
— *Murray Grigor, Film-maker*

"This collection of poems and illustrations by George Wyllie will make you ask questions and have you laughing out loud in equal measure. Wyllie loves to draw with words and, on paper, he has as fine a line as he does in steel."
— *Jan Patience, Arts writer*

Some serious, Some not, Some not even that
—

VI

Some serious, Some not, Some not even that

—

GEORGE WYLLIE
Artist, husband, father, grandfather & dear friend

—

On the celebration of your 90th birthday Dad,
Love Louise and Elaine

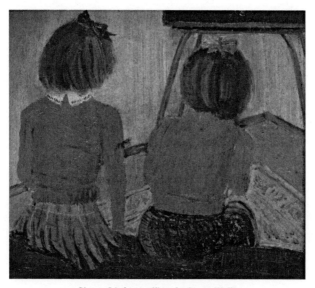

Sisters, Lisdrumgullion, by George Wyllie

VII

Some serious, Some not, Some not even that

—

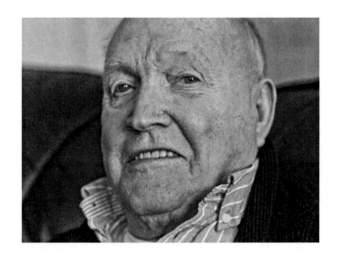

Some serious, Some not, Some not even that
—

"But then we must look for the intentions of nature in things
which retain their nature, and not in things which are corrupted."
— *Aristotle*. "Politics, Book One."

IX
Some serious, Some not, Some not even that
—

CONTENTS

Some serious, Some not, Some not even that

—

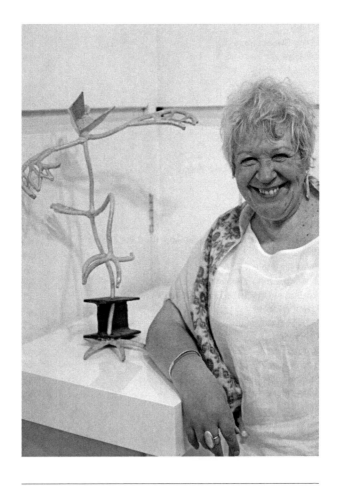

Some serious, Some not, Some not even that
—

George Wyllie is a seriously playful artist. All his life he has been driven by the desire to play, driven to make things, to ask the big questions, and the wee ones too, as freely, as straight-forwardly, as outrageously and with all the fun, the indomitable life force of a child, all the long-lived courage of a wise man, the whys-man, who knows the worst, as well as the very best, that human-kind is capable of. He celebrates us in all our glory and ludicrousness.

His structures are poems, just as all the poems in this book are structures.

He makes me happy in the way that ooh... Alan Davie, Joan Miro, Mozart, Edwin Morgan, Alexander Calder, Robert Burns in merry mood, Don Marquis, e.e.cummings, The Simpsons, Adrian Mitchell, Ivor Cutler, John Sampson (my friend who can play two flutes at once), can make me happy.

My good friend, and George's, Bill Paterson, who worked with him on *A Day Down A Goldmine*, once suggested George and I should do some sort of a theatre piece, a revue, together. Just because we had a title, *Wyllie & Lochhead*, he said would work well (at least here in Glasgow and with wrinklies like oorsels...). I was well chuffed that Bill thought me fit for a collaboration with such illustrious company. Never got round to that yet, did we? But – for George's seventy-fifth birthday – I was proud to be asked to write a poem in honour of the occasion. Whether it's any great shakes *as a poem* or not, looking at it now, well, the fundamental things apply, and I feel I can't do better than reprise that now, as I wish this fine and long overdue book well.

A WEE MULTITUDE OF QUESTIONS FOR GEORGE WYLLIE

By Liz Lochhead

—

Who is the man
'it pleases as much to doubt
as to be certain'?

Whose faith
is in the questioned faith?

Which Great Scot
(pronouncedly Scottish) pronounces
Scul?ture
most Scotchly with a question mark and a
glottal stop?

Who puts a question mark at the centre of everything?

Who lives unbowed under the slant of Scottish weather,
loves the white light of stones,
walks on wiry grass
and, feeling the electric earth beneath him,
turns his wide gaze to the open sea?

Who was the young sailor
who walked in a place of ash and char, fused glass, bone?
Who saw that, aye, rocks *do* melt wi' the sun
and let pulverised granite run through his fingers
like *the Sands of Time shall Run?*
(The name of the place was
Hiroshima
and in the middle of the word
was the hugest question-mark.)

Who will surely
interpret for us the monograms of the stars?

Some serious, Some not, Some not even that

—

Who is the man
whose name belies his nature?
(for 'wily' he is not; there is
craft in it, and art, but no guile. He is true
and straight, his strategy is honesty, and to ask –
in all innocence
in all experience –
the simplest, starkest, startling
questions.)

Who makes biting satire out of mild steel?

Who wishes to avoid Incorrect Assumptions leading to
False Conclusions? Wants us to question mark,
yen, buck, pound?

Who in *A Day Down A Goldmine* asked us to resist
the Golden Fleece, the Big 'I-con'
that would swizz us all to sell our souls?

Whose
Berlin Burd
faced an absurd
obstacle?
(Which the bird keeked over
and The Wall keeled over.)

Who, one Christmas, made
gorgeous guano-free robins
cheep in George Street, Edinburgh,
more multitudinous
than were starlings once in Glasgow's George Square?

Some serious, Some not, Some not even that

—

Which George is the Captain of *The Question Mark*
and Daphne his first mate?

Whose Jubilee
was happily misspelled *Jubliee* on page thirty-five
of his lovely, jubbly, jubilee catalogue?

Who decided a locomotive might descend a staircase
and a tramcar might have wings?

Who made the out of order
Standing Stones walk?
Who made Holyrood into almost Hollywood
for the Festival Fringe?

Whose spires inspire us,
unquestionably celebrate?

What the devil was the de'il
wha danced away wi the exciseman?
(Art did! Art is the very devil that danced
awa wi the exciseman.)

Who is the Mad Professor up all night in the attic
inventing *The Great British Slap and Tickle Machine?*
Who is our ain
National Genius, wir true Caledonian McBrain?

Some serious, Some not, Some not even that
—

Who speculates about what is
below the surface, douses, divines?
Whose rod is not a Y
but a why? Whittled to a ?
(His *'by hook, by crook'* he advances with, slowly
over rough ground in his good grasp;
his shepherds crook;
his boat hook
hauling us aboard – hang on to your sou-westers,
shipmates, it'll likely be a bumpy ride...)

In the dark spaces of our heads
divers, multitudinous, unmarked, the questions float
 above a straw locomotive and a paper boat.

Some serious, Some not, Some not even that
—

Some serious, Some not, Some not even that
—

George Wyllie MBE (born 1921) is a Scottish artist, writer and scul?tor. He has lived in Gourock, Scotland, for the last 50 years.

Throughout his career George Wyllie has developed an imaginative and individual way of Being. On this journey as an artist and thinker he has dealt in absurdity and parody, questioned society's orthodox ways of thinking, unearthed the true nature of things, and surpassed the commonality of Western thought in a random and unpredictable way.

There has never been a guarantee within Wyllie's work, only a question (mark), notably found in the centre of all things. He carries this out in an almost metaphysical or sometimes pataphysical way. A true equilibrist who questions with a neo-shamanic twist.

The belief that art can change our ideas and ways of Being is an intrinsic element in his thought process. As is the premise that real art and creativity has to come from within oneself in an uncompromising and non-corporate way. Underlying all these great depths you stumble upon an unquestionable humour and intellectual primitivism inherent within many of the poems and illustrations contained in this book. As the title of this book suggests, Some serious, Some not, Some not even that!

George Wyllie has exhibited in the UK, Europe, India, and the US and many of his monumental scul?tures are permanently installed in environmental settings. He is best known for *A Day Down a Goldmine, The Straw Locomotive, The Paper Boat, Equilibrium of Spires,* and *The Cosmic Voyage.* In 2005, he was awarded an MBE for his outstanding contribution to the arts.

SOME SERIOUS, SOME NOT, SOME NOT EVEN THAT

—

BY GEORGE WYLLIE

TO BE

…What useless thing
 will I do today
 in the name of work
 as opposed to play…

OR NOT TO BE
?

KASPAR WILL BE PLEASED

George Wyllie

—

and I will not express the resin with such passion
and I suppress the egg of fate
and I sauce the smoke of paradise
and I abort below me the hem suggesting approbate

and I will wonder fringe excesses
and I am deaf to stockinged cats
and I relate congested eels and pansy bearings
and I will not extinguish bureaucrats

and I agree to mensuration
and I expect a globuled mile
and I will lift the tilted cabbage
and I know 93(b) + 2 is not full

Some serious, Some not, Some not even that

—

Where'er
a
poemetician
and prosologist
goes
they leave their own trail
of
poemes n' prose

Some serious, Some not, Some not even that

—

POUNDS AND PENCE
George Wyllie
—

A genius once said
of years still ahead
that energy is there
from water and air
from earth and the sun
and before it's all done
we could live a long while
in natural style.

That is...

If man could develop
power to envelope
the whole of the globe
in an exploratory probe
to dismiss as trash
our dependence on cash
and usurp pounds and pence
by organised sense.

Some serious, Some not, Some not even that
—

A BIRD IS NOT A STONE

George Wyllie

—

a bird
is
not
a stone

Some serious, Some not, Some not even that

—

PACKAGE TOUR
George Wyllie

—

British as roast
scouse tourist and wife
formidably perfumed
in best duty free
ponging outsize sun-glassed air-conditioned way
to cruise Ionian seas.

Far from brick and dereliction
the sun fails to bring to life
her high street dress
his multiple shirt and trophied trilby
dowdy as from whence they came.

Yet here they are
within the touch of olives
for fourteen days and two night flights
collecting memories
butterflies in a jam jar
to take home
where scent and souvenirs impress
and worsted is the thing.

Some serious, Some not, Some not even that

—

I MAY GO DOWN TO THE SEA AGAIN

George Wyllie

—

Snappy German motorship
with Art Deco funnel
sailing weekly through the Channel
in any sort of gale
containers stuffed with
liebfraumilch
hi-fi
pumpernickel
terylene evening suits
and precision machine parts
(the latter made from scrap from British coasters).

Some serious, Some not, Some not even that

—

JAZ
George Wyllie

—

Jazin jamin
raz mataz
hairi-arst gize
givin out jaz
a 1 ana 2
havin a blo
nuno yo goddam
quic quik slo
jamin th bluze
i's iz tite
takin th rif
bluin th night
hairi-arst jaz
swetin til don
mude elzwer
stil goovz on

Some serious, Some not, Some not even that

—

ABORT ABORT

George Wyllie

—

When God made ladies
and God made men
there was mentioned the figure
of three score and ten
but as ladies and men
go boom boom boom
the world will ultimately run out of room
might I suggest
a device is needed
to explode inside us
should this be exceeded.

Some serious, Some not, Some not even that

—

THESE QUESTIONS MUST BE ASKED

George Wyllie

—

How did the great Creator
in his workshop making works
happen to shovel
humanity
into me?

Why not a ladle-ful of dog stuff
a teaspoonful of frog or sparrow
or pinch of plankton?

Was I first in a queue
programmed by celestial computer
is there a heavenly quota about such things?

Somehow
that shovelful
means greater things are expected from me
like having to ask such questions.

Some serious, Some not, Some not even that

—

THE HARD SELL

George Wyllie

—

A salesman called on us one day
And from the midst of his array
utensils to clean everything

> he cast his spell,
> for a quick sell.

We'd been selected we were told
To receive from him a pot of gold
Well – really its equivalent
A heaven sent gift for wife and me
To acquire very nearly free
A machine which he would demonstrate
Would render others out of date.

> We sat transfixed
> By his bag of tricks.

The sell commenced and with his stuff
cleaned the curtains, gobbled fluff
devoured the dog's discarded crust
embarrassed carpets yielded dust

> but smiling tension on his face
> indicated change of pace.

Some serious, Some not, Some not even that

—

Commission instincts could be seen
where previously the smile had been
of course his time was ours of course
– of course if we would sign and pay
some now and some another day
he back-slapped – if we paid the lot
some reduction might be bought.

> Necessitous to better us
> he didn't want to go
>
> – but we said "NO".

exActly
(eager-beaverness)
exaACTly
we could ORganise it
as an Answer to this pArTICular problem
we could do it ThIS way
we could ınVite Ideas
we could have a vIEW DEpArture
social AWAreness
IS ONE Of the factors
we mUst tALK tO tHE pEOPLE
WE Must Find a Way Out
YYooUU TelL MmeE
WHAT IS IT WE REALLY WANt
?

THE DIGNITY OF LABOUR
George Wyllie

—

The lady with the heavy legs
and varicose hose
laboured her way to reach the door
then tightly bend and push
through low letter-box
a clutch of coupons
selling things
at ten pence off
and five pence off
and two pence off
and a summer snowball competition.

Tight bending done
commercial mum
trudged heavy legs
back up the path
her second best coat
insulating weary perspiration

Today her children
had not clutched that well loved garment
earlied to school
with sparse maternal ceremony
dust and dishes behind her
she left
to compromise the suburbs.

Some serious, Some not, Some not even that

—

Man to man
where'er you be
can very nearly
equal be
provided it is understood
and realised that it's essential
to perpetuate the differential
fundamental
to a boss
for equality means
significant loss

OK?

In a moment or two
 the hands of the clock
 will reach the time
 for the old one
 to retire

And at that moment
 the out-stretched hands of well-wishers
 present whatever to amuse
 and interest the remaining years
 help thumbsuck time away.

 SPEECH!

Polite thanks
 dear fettered colleagues
 and...(clearing the aged throat)
 ...would just like to say

 BALLS

ALWAYS WITH US

George Wyllie

—

Supposing
efforts could be made
to elevate
the lowly paid
to higher in the wages scale
regrettably
the plan would fail
for beneath the newly elevated
would now be others
underrated
supposing
efforts could be made
to elevate
the lowly paid.

Some serious, Some not, Some not even that

—

Across the mahogany table
opposites
sat the humans
and the humanoids

The humans were a troublesome lot
and along with eagerness to seek solutions
came mistakes
some experience of life
a touch deviousness
attempted avarice
laughing wisdom
and badly organised justification
for their own well-being

Programmed only to smile
and deflect truths
the humanoids
in their own polite time
dismissed the babble
which then withdrew
(it was nearly lunchtime)
and it shuffled

The echo becoming silent
along the corridor.

Some serious, Some not, Some not even that

—

Give gifts of cheese this Festive time
Stilton, cheddar, Cottage Creams
Consume them after pies and pudding
– ensure erotic Christmas Dreams.

I think I'd rather go to hell
Than Watermelon Citadel

Some serious, Some not, Some not even that

—

A SCOTSMAN LOOKS AT THE ROSE

George Wyllie

—

I like
no
I love
the English
because they
bum
not that it matters to me that they do
but they do
and they are better at it.

A fine heritage
have the English
and
they let you know about it
quite right too
for we would not know
about this better heritage
if they did not
bum.

Some serious, Some not, Some not even that

—

They are
nearly as good as us
no probably better
there have always been more English
more to
bum
therefore better.

Mind you
I once met an even better one
who didn't
bum
I liked him too.

Oh
if only we could do it
I think we might be better
but
we can't
and they can
and therefore better

Great Bums.

MACDIARMID'S REEL
George Wyllie

—

Not always a bonnie tune
played determinedly
on love hate bagpipes
rousing wicked confidence
to up and over then down
to attack the condescending annoyance
and the inspirational dagger
of a smiling enemy
a skirling opiate
doing much to rouse
and less to...
(I nearly said "raise")
...but I remembered the beach
and his understanding
of stones

Some serious, Some not, Some not even that

—

ONE OF OUR CHOC ICES IS MISSING

George Wyllie

—

Reports are coming in of a
Slight brown slick in the North

Sea and a small piece of

Driftwood has been picked up.

Some serious, Some not, Some not even that

—

I think that is the colour we want
that spot of blood on the door there, Daphne.

Some serious, Some not, Some not even that

—

IT DOESN'T ADD UP

George Wyllie

—

If inches were like money
and changed a bit each day
we wouldn't find it funny
when measuring let's say
a coat, a carpet, piece of wood
or anything else you'd care to name
to find the inch had changed a bit
from mensurial pressure brought on it.

If inches were to fluctuate
like money
I would speculate
(like those with money do)
– that chaos would ensue.

(For EEC use, 'metres' may be substituted for 'inches')

Some serious, Some not, Some not even that

—

MONTH

George Wyllie

—

To try to get statistics neater
thirty point four one six repeater
would be the number of days in a month
if all the days were equal.
that is excepting each leap year
which if included would I fear
cause the following figure to arrive
three zero point four three seven five.

I am the clumsy shaman
with the stainless eagle at my door
and the wild geese flying over the power line
recognise the totems of my clumsiness
but I will practise
seduced completely by birch and quartz
usually held in a stainless clasp
held loosely by red rope
in equilibrium
and below my Spire
an arrow
at last pointing and swinging
spiralling
the shameless realisation
of total Being

OFF COURSE
George Wyllie

—

what negates adherence
to the definite
defined inner course
needle-firm
steady sure and right
aware of seduction
and the easy way
of wallow
knowingly denying
vital correction
and the magnet
tapped and tired
needlessly beaten
becoming impotent
to its lodestone
?

Some serious, Some not, Some not even that

—

HE

was the man
who wrote white papers
for the government
he looked up
and there

SHE

was
adjacent
so convenient
they wrote
white papers

TOGETHER

X

Andrew
woke up
and stretched himself
between each leg
of the bed posts

GOOD

Andrew
didn't know
that one day
he would end up
that Saintly way

FROST

George Wyllie

—

Silver grey
frozen indicator
of all is well
thaw slowly
to savour
the incision
and health
of your transient
cold
yet warming
my hand blowing
being

Some serious, Some not, Some not even that
—

THE BIPLANE

George Wyllie

—

The lazy sound of a biplane in the sky
arching against the hazy summer blue
a rival to the bumble bee below

Silver fabric quivering and taut
varnished laminations streaming and forcing the air
content to zephyr me

Warm in long green grass and clover place
sucking a blade
I listen upwards.

Some serious, Some not, Some not even that

—

Simply
my dear
and sometimes
rather crude
and boisterous
comrade
simply
being a worker
is not in itself
sufficient qualification
for membership
of
the Salt of the Earth
Society.

The busy army
of regimented imaginations
singularly accommodates singular imaginations
of unimaginative others
…but in solitary
repeat solitary
and finding the stone
where no others but you
imaginatively imagine
breaking ranks
with unimagination
a lonesome working way
to honourable discharge
that's the ticket!

THE CLARSACH

George Wyllie

—

Half-close your eyes
and watch
the fingers
the nails
picking and patting
the music
tingling air

Some serious, Some not, Some not even that

—

ON PULLING DOWN A STRAW STATUE

George Wyllie

—

When walls come down and statues fall,
there's change abroad an' a' that,
but it takes the mind off closer things
– for it can happen here an' a' that.

For a' that, and a' that,
pull empires down before they start
– and all that jazz, an a' that.

Some serious, Some not, Some not even that

—

A CONFESSION
George Wyllie

—

– from an active, but pleasant, Anarchist.

In a funny way
I am a revolution.

Some serious, Some not, Some not even that

—

BUFFET CAR
George Wyllie

—

I suppose it's the soup
and the tart
and the gravy
that raises the stains
on the trousers of waiters
who wait on the trains.

Some serious, Some not, Some not even that

—

ON THE WRONG TRACK

George Wyllie

—

Diesel engines never seem
quite compatible to steam
or even electricity.

Alien to a railway track
blue exhaust and no smokestack
no wet steam or smoke that's gritty

Even the electric train
is cleaner though it's very plain
its appearance is a pity.

Why did they have to supercede
steam engines charging at full speed
on every inter-city?

Some serious, Some not, Some not even that

—

DEEP LITTER
George Wyllie
—

Erst Nature's profit comes to harm
it's safe within the Battery Farm.
the same delusion to the heart
is the Gallery that encloses Art.

Some serious, Some not, Some not even that
—

THE INADEQUACY OF HAVING AN APPETITE LIKE A BIRD
George Wyllie

—

One swallow
doth not make
a supper.

Some serious, Some not, Some not even that

—

BLUE BLODGE
George Wyllie

—

Consider a girl with blue blodge eyes
cantilevered lashes
smoked like ashes
nature enhanced
mysterious moorish
lined like a coach
and promising promise
and whilst blue blodge eyes
emphasise fragility
they have the ability
to do just not that
for dear pussy cat
mascaraed mood
misunderstood
turns the head
bait for bed
or beauty instead
and the eternal puzzle lying
behind the blodge of blue eyes eyeing

Some serious, Some not, Some not even that

—

SOUTHERN SCHOOLGIRL

George Wyllie

—

On a railway station there is always a schoolgirl
uncertain and cocky, untidy and scrubbed
unconcernedly knowing yet eyes flashing shy
some awful dad's daughter but certainly loved.

Abominably fashioned in colour and shape
distorted uniform glimmering style
twisted belt bulging satchel all clicking along
and mother despairs but the same mother smiles

Never a solitary schoolgirl for long
a wave and a shriek greets her friends who've been clicking
and clucking from different directions
from hated parents, awful parents, reluctantly loved.

Some serious, Some not, Some not even that

—

My heart's in the Metropole
My heart is not here
My heart's in the Metropole
a-chasing the dear
wee Moxon Young Ladies
tip-tapping thru' heather
in rich amber sunsets
accordion weather
and the platinum trilling of a high-heeled soprano
with the list of first violin attaching piano
a big velvet tenor all cairngorm and buckle
and two tartan comics MacMickle and Muckle

[INTERVAL]

My heart is not in the Highlands
Where perhaps it should be
– It's in the METROPOLE THEATRE featuring

…A Highland Loch…Real Sheep and Rab the Collie…
Grannie's Clachan … Six Shetland Ponies…A Waterfall…
And…

The City of Glasgow Police Pipe Band
…flowing down to Row C.

AUCHTERMUCHTY TIME IN AULD GLENCOE

George Wyllie

—

Sittin' wi' a haggis in a shieling in the glen
eatin' up ma' porridge in ma' wee bit but and ben
I heard a mavis singing in the gloamin' o' the nicht
wi' ma' ain dear Mary – a bonnie bloomin' sicht
as bonnie as the bluebells ever sclimin' up a wa'
ma' heart's a ba' that's stottin' for ever and for aw'
like mince is meant for tatties, like heather is tae bell
I'll 'lo'e' you bonnie Mary 'til the snawballs melt in hell.
O

Some serious, Some not, Some not even that

—

LINES TO DAWSON
George Wyllie

—

I send this to you at Kilmany which is near the south bank of the Tay
in very cold conditions in December and on the eve of Hogmanay
for on this very particular day I have reached the age of 75 years
but still keep up with and on occasions do more than my peers
which is made considerably easier as long as there are a few
good friends and other members of the population just like you.

ODE TO A SAFETY-PIN

George Wyllie

—

In 1849 in New York City
Walter Hunt was a figure of pity
destitute – without a cent
couldn't buy food or pay the rent
stomach empty, body thin,
he made the very first Safety-Pin
for poverty was the great incentive
which encouraged him to be inventive.

Walter's finances were extremely tight
and he had to sell the copyright
for a hundred dollars – a meager sum
to save him from becoming a bum
but the buyer made a fortune quicker
for that is the way of the city slicker
to be financially manipulative
and exploit the brains of the innovative.

Some serious, Some not, Some not even that

—

CLACH-GRIAN
George Wyllie

—

I am moved
– my apologies to you all
for primitive passion – transparent emotion
scarce amongst commodities
but which I now release
not shy nor unbravely contained
but free
clear in the air
in the all of time and in every stone
together willing expression
to the unsuppressible

on the Isle of Mull
the spirit of that place
and of the distant Meti
(I know this for they told me)
is alive in the dwelling stones
on the ridge below the pinnacle of Ach-na-Stac
silent over the field and beach of Calgary

Some serious, Some not, Some not even that

—

My Spire is the happy compass
spiraling within and around
cosmic quartz
charging the spirit
universal light
beyond suppression

sun-stone.

RIDDLE

George Wyllie

—

Red outside
and white within
golden spots upon my skin
…What am I

?

*(The solving of this neccesitated fruitless world-wide travels
then back to a back garden where it was solved by an elf)*

…Goddamit Sir
(said the elf)

It's a

STRAWBERRY!

Some serious, Some not, Some not even that

—

THE SPORTING LIFE
George Wyllie

—

He stumbled
from the womb
of the tunnel
already
a footballer
 running out
on to the pitch
of life
which is not a bad analogy
for he took to it
naturally
(yes, he was an absolute natural)
and he could
 kick
head
 dribble
as though
(as already mentioned)
born
to it.

He kicked
 headed
 and dribbled
through
his life
and his name
(his illustrious name
is now recorded
somewhere
in a
sportsman's
hall of fame
a wee red book
and
(as licensee)
over
a pub
on
Dumbarton
Road.

Some serious, Some not, Some not even that

—

SOME SERIOUS, SOME NOT, SOME NOT EVEN THAT

—

BY GEORGE WYLLIE

A BIRD IS NOT A STONE

George Wyllie

—

Some serious, Some not, Some not even that

—

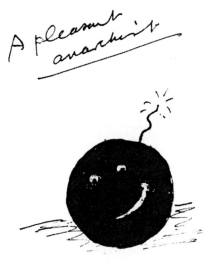

Some serious, Some not, Some not even that

—

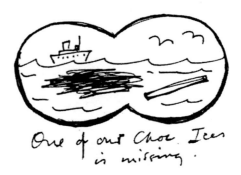

One of our Choc. Ices
is missing.

THE INADEQUACY OF HAVING AN APPETITE LIKE A BIRD

George Wyllie

—

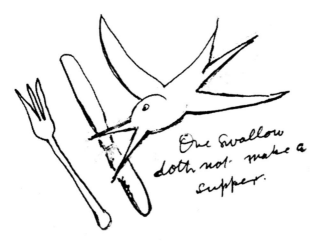

One swallow doth not make a supper.

Some serious, Some not, Some not even that

—

STILL THE NIGHT

George Wyllie

—

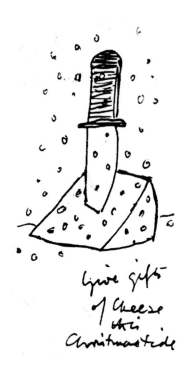

Give gifts
of Cheese
this
Christmastide

Some serious, Some not, Some not even that

—

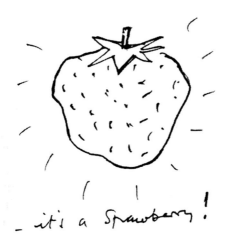

_ it's a Sprawberry!

Some serious, Some not, Some not even that

—

Thank you all!
from The Friends of George Wyllie

—

*Without the help and support of the following people this poetry
book would never have been published.*

The Friends of George Wyllie
support and guidance

Pete Rossi
design & layout

Karen Cunningham
Aye Write! Festival

Alma and Leslie Wolfson
charitable trust donation

Chums Club
membership fees

Jan Patience
editorial support

Lynne Mackenzie
marketing support

Angela McEwan
publishing support

Lightning Source UK Ltd.
Milton Keynes UK
UKOW050556250212

187884UK00001B/2/P